COMPLICIT

Joe Sutton

COMPLICIT

OBERON BOOKS
LONDON

First published in 2009 by Oberon Books Ltd
521 Caledonian Road, London N7 9RH
Tel: 020 7607 3637 / Fax: 020 7607 3629
e-mail: info@oberonbooks.com
www.oberonbooks.com

A catalogue record for this book is available from the British
Library.

ISBN: 978-1-84002-911-6

Printed in Great Britain by CPI Antony Rowe, Chippenham.

To my oldest son, James

Characters

BENJAMIN KRITZER
An award-winning journalist, 49

JUDITH BROWN
Ben's wife, somewhat younger

ROGER COWAN
Partner, Cowan & Doggett, 51

PLACE: In and around Washington, D.C.

TIME: The years just after the attack.

SETTING: The play takes place in a variety of locations and should be staged on a simple, unified set. A pair of chairs and a door should suffice. In addition, there are a number of phone conversations. These should be staged without use of a phone, the two actors merely facing the audience. Taped clips from a television talk show are shown throughout.

NOTE ON PUNCTUATION: A dash at the end of a line (–) indicates an interrupted speech. An ellipsis at the end of a line (…) indicates the speaker trailing off. Internal ellipses can mean several things, in some cases pauses, in some cases self-interruptions which should happen quickly.

AUTHOR'S NOTE
Complicit is a work of fiction. It contains allegations about the policies of the United States government and its 'War on Terror' that are solely the invention of the author.

Complicit was first performed at The Old Vic Theatre, London on 7 January 2009, with the following cast:

BEN KRITZER, Richard Dreyfuss

JUDITH BROWN, Elizabeth McGovern

ROGER COWAN, David Suchet

Directed by Kevin Spacey

Designed by Rob Howell

Lighting by Howard Harrison

Please note: the text was printed before the play finished rehearsals. Therefore it may differ slightly from the text performed.

Act One

Lights come up on a hooded man in a folding chair. He is handcuffed. His hands are behind him. In front of him is a large metal washbasin sitting on top of a sturdy metal stand. The man himself is sitting bolt upright, unmoving, frightened. We watch him for a long moment.

A man in a black ski mask appears. He glances over at the hooded man and then moves away. He busies himself with some paperwork, a clipboard perhaps. He then looks back at the hooded man and picks up a garden hose. He walks it over to the washbasin and turns on the water. The sound of the water echoes loudly as it pours into the basin. We listen for a long moment as the bin continues to fill.

Blackout.

The lights then come up on BEN KRITZER. Sitting alone staring in front of him, BEN is dressed in a tie and a button down shirt. He looks as if he is off to work. He isn't. He is waiting. With a cup of coffee in his hand. When suddenly his wife JUDY appears. The minute she does so, she looks over at him, the air between them tense. Something momentous is about to occur.

JUDY: Sleep?

BEN: Not… (*Then, thinking better of his first answer.*) Yeah.

JUDY: How much?

BEN: (*Beat.*) All night.

She stares at him – disbelieving.

JUDY: From when?

He glances at her, irritated. Then turns back.

BEN: Midnight. After midnight. One.

Pause.

JUDY: Till?

BEN: Honey… (*Irritated.*) …what do you want from me?

JUDY: I just want to know if you slept.

BEN: Yes. I slept!

Beat.

JUDY: Well?

BEN: (*Beat.*) No.

JUDY busies herself, trying to make herself occupied. In truth she is hovering, unable to pull away.

JUDY: Eat?

BEN: (*Beat.*) Yeah. A little. Toast.

JUDY: Is that going to be enough?

BEN: I don't know. (*Then.*) Yeah. We get a lunch break, right?

JUDY: I don't know. (*Beat.*) Do you?

BEN: Yeah. I would think. (*Again with a small laugh.*) Can't keep you all day.

JUDY: And this will keep you till then?

He nods.

Did you see the kids?

BEN: Yeah.

JUDY: You gave them lunch?

BEN: I gave them money.

Beat.

JUDY: So what, you –

BEN: (*Loud.*) I'm waiting for Roger to come!

Beat.

JUDY: He'll take you?

BEN: He'll take me.

JUDY: That's what you arranged?

BEN: That's…yes.

JUDY: And you'll talk to him in the car?

BEN: (*Dry.*) I would think so, yes.

JUDY: About what we talked about.

BEN looks over; he nods.

Because I don't think…I think it's important for you to discuss that.

BEN: We will.

JUDY: Have you? Up until now. Have…have you even broached it?

BEN: Not, no. Not…no.

JUDY: You don't think you should?

BEN: I do think we should. We just haven't until now.

Beat.

JUDY: I'm not sure he has your best interests at heart.

Beat.

Ben, did you hear me? I don't –

BEN: I heard you.

JUDY: Do you agree?

BEN: No.

JUDY: You think –

BEN: Judy! This isn't helping.

Pause. A long pause.

JUDY: Who's going to be there? From the newspaper? Anybody?

BEN: No.

JUDY: Why –

BEN: Judy, it's a grand jury. It's private. My lawyer can't even be in there. (*Slight pause.*) Roger can't be in there. It's just me.

JUDY: Somebody could be in the hallway. Giving you support. (*Slight beat.*) Someone could be there.

Beat.

BEN: Well, no one is. No one's going to be there.

JUDY: Was this discussed?

BEN: I don't know.

JUDY: Did you discuss it with them?

BEN: No.

JUDY: Why not?

BEN: (*Suddenly enraged.*) Judy, I don't understand what you're doing here. What are you doing?

JUDY: I'm just… (*Flustered.*) …I don't know, I –

BEN: Judy, look, just…let it go, okay? I know you're nervous. And I'm nervous. Believe me. But just… Please.

Pause.

JUDY: Are you scared?

BEN: What?

JUDY: Are you scared?

Pause.

BEN: Yes.

JUDY: Good. You should be. You…don't be a hero, okay? Don't be a fucking hero! Okay?

She waits for him to answer.

Ben!

BEN: Judy!

BEN closes his eyes, truly exasperated.

What you think's important, and what's really important are two different things.

JUDY: What do you mean?

BEN: I mean –

JUDY: Ben, you are taunting them. Okay? I don't know why you are doing it, but you are putting…and Ben, look, I'll be candid with you, this is scaring the SHIT out of me. Okay? I did not sign up to be on an enemy list. I don't want my phone…I mean, fuck, my 'phone'. I don't want every part of my life, my business, my children, when I walk down the street, I don't want… 'oh, there's Ben Kritzer's wife.' 'Ben's in jail, you know.' 'Poor Judy.' (*Slight beat.*) I could do without that.

BEN: (*Seething.*) So this is about you.

JUDY: Do you think it ISN'T? Do you think this is a decision for you to make alone? That only affects you? You think your kids… I mean, forget being invited to Mort Bellman's house…forget the board of Jay's school. Forget being able to take a VACATION next year…do you think this doesn't affect me when I try to place my work? When I try to MAKE my work? (*Slight beat.*) We are a *family*, Ben. What happens to one of us happens to ALL of us.

BEN: So what would you have me do?

JUDY: Think! Okay? Think! (*Slight beat.*) About whether you are doing the right thing. About whether…this is the only way…for you to go forward. Maybe… (*Hesitant.*) …you know…maybe –

BEN: Maybe what?

JUDY: Maybe you give him what he wants. (*Slight beat.*) Maybe you give the prosecutor what he wants.

BEN: I can't do that.

JUDY: Why not?

BEN: Judy –

JUDY: Ben, you have a *family* here!

BEN: I know that. (*Long beat.*) I know that.

> *The doorbell rings.*

Get the door, will you?

JUDY: Ben –

BEN: Judy, I understand what you're saying. Okay? But you have to realize, there is no easy out here. There is no way to finesse this. Pretend it didn't happen. I wrote what I wrote. It had consequences!

JUDY: But those consequences are not prison. Ben. They needn't be prison. You don't have to prove a point and go to prison!

> *Beat.*

BEN: Get the door.

> *Beat.*

Judy, please. Get the door.

> *After a moment JUDY goes to the door. She opens it. It's ROGER COWAN.*

ROGER: Hello Judy.

JUDY: (*Stiffly.*) Roger.

ROGER: May I...come in?

JUDY stiffly steps aside. ROGER quickly walks in. He sees BEN sitting across the way. There's a silence.

(*Finally.*) You ready?

BEN: Yeah.

JUDY: Roger?

BEN: Judy!

JUDY: (*Loud.*) May I talk to him!!

A silence. She turns to ROGER.

May I talk to you?

Beat.

ROGER: Sure.

JUDY: Why is this happening?

BEN: Judy.

JUDY: It's a simple question, Ben. I'd like to hear your lawyer speak. Why is this happening?

Beat.

ROGER: There are many answers to that. A variety of viewpoints.

JUDY: Give me a few.

BEN: This isn't the time, Judy.

ROGER: We have to show up on time.

JUDY: Give me a few!

ROGER: The prosecutor wants it to. That's the easiest answer. He's a dog.

JUDY: Give me another.

ROGER: (*With a sigh.*) I –

JUDY: You said there were a few, give me another!

ROGER: It's a brave new world. Lines are being crossed. Power is being adjusted.

JUDY: (*Mocking.*) Tell me, o wise one…what does that mean?

ROGER: We're at war. The executive branch is flexing its muscles. The other branches are seeking to place limits.

JUDY: You're going to have to be a lot clearer than that.

BEN: At another time, all right? (*Seething, staring at her.*) At another time.

JUDY looks over at him and steps back. She can't take it further.

(*To ROGER.*) Let me get my jacket.

ROGER nods, and BEN crosses from the room. ROGER glances nervously at JUDY.

JUDY: I just don't understand.

She waits for an answer.

Roger, I just don't understand.

ROGER: I know.

JUDY: The war, the entire…what the entire edifice coming down on Ben's head?! I just don't understand!

ROGER: Look, partly it's to make sure there aren't other Bens. Partly it's to make sure there aren't other people talking to Ben. (*Pause.*) It's happened. This kind of thing happens. The Dreyfus affair. You know?

JUDY: What do you mean?

ROGER: I mean –

JUDY: (*Agitated.*) Why do you say the Dreyfus affair? What do you mean!

ROGER: I –

JUDY: This is because Ben is Jewish?!?!

ROGER: No –

JUDY: What do you mean 'the Dreyfus affair'?

ROGER: A bad example. I didn't… I just mean that one person, an obscure person, can have – not that Ben is obscure – but a…you know, a person outside the normal… the halls of power…can become the focus of the story. The center of the… (*Changing tack, summing up.*) …where we are, as a nation, is in some way reflected by what's happening to Ben.

JUDY: Roger, I want you to understand something. Ben is a father. Okay? Ben is a father.

ROGER: I know.

JUDY: Whatever else Ben is, he is a father. He is a member of this family. (*She is starting to cry.*)

ROGER: I know. And I will… I know.

JUDY: What were you going to say? You will what?

ROGER: When the time comes, if the time comes, I will try to let the people who should know that fact know that fact.

A silence. BEN enters the room.

BEN: Know what fact?

JUDY: (*Shouting almost.*) That you're a father!

This last she says angrily, whipping around on him. BEN stares back at her, debating whether to respond, and decides not to. He turns to ROGER

BEN: Let's go.

JUDY: Do you acknowledge that, Ben?

BEN: Of course.

JUDY: Will you weigh that fact in what you do here?

BEN: Yes. (*Then:*) Judy, listen to me. I'm not... Roger, help me with this. I'm not going to jail. Right?

With this last he looks to ROGER. ROGER doesn't answer.

(*Louder, a bit unnerved.*) Roger, I'm not going to jail, right??

ROGER: (*Beat.*) It's unlikely you'll go to jail.

JUDY: (*Jumping in.*) But it's possible. Is that what you're saying? It's possible.

ROGER: It's possible, yes. (*Then, to BEN.*) My sense is that the prosecutor doesn't want to throw you in jail. But if he doesn't like your answers, or...you refuse to answer...then, yes, I think he...there's a possibility... (*But he can't finish it.*)

BEN: I could go to jail.

ROGER: Yes.

Beat.

JUDY: (*Quiet, intense.*) How does he avoid it?

ROGER: As –

JUDY: (*Loudly.*) WHAT IS HE AFTER, ROGER ? (*Then, quieter.*) What is he after?

ROGER: Ben's source.

JUDY: (*To BEN.*) Are you going to give it to him?

BEN: (*Quiet.*) No.

JUDY: (*To ROGER.*) So then what?

ROGER: So then...

JUDY: I just don't understand Roger! Are you playing a game here? How does this work? You say he wants Ben's source. Ben says he doesn't want to give him the source. He's gonna ask for it… Ben says, you know, whatever…and he doesn't go to jail?

ROGER: Ben will say… (*Quickly amending that.*) …what I've instructed Ben to say…is that he's standing behind privilege. That the edifice of American journalism is, yes, hinging on this. And that the courts have said prosecutors have to exhaust all other methods. Before they can compel a journalist to give up a source, they have to first look at *every other way they can get this story.* I don't think they've done that. I don't think, if we have to go outside and face the judge, I don't believe the judge will agree they've done that. And so, yes, I do think he'll let Ben stand on privilege. There are many other things Ben will testify about. That he can testify about. I don't think he'll have to testify about this.

BEN: (*To JUDY.*) Okay?

JUDY stares at him a moment. Then nods. BEN nods back at her. Then turns to ROGER and nods at him. He turns to go.

JUDY: Ben!

She then turns to him, throwing her arms around him, embracing him hard. BEN embraces her back, his eyes closed – he, trying to hold back tears as she cries.

BEN: I'll be okay. (*After a moment.*) I'll be okay. (*Then:*) So will you. (*Then to ROGER:*) Come on.

BEN exits.

Suddenly a television screen flickers to life and we see the words 'months earlier.' This is then followed by a clip of BEN on a british television show, a political chat show, not unlike those we've become accustomed to on american television. Sitting in front of a conventional back-drop, coffee cup in hand, BEN faces his opposite, a questioner with a clipped 'bbc' accent. The man remains just off

camera, sitting across from him. As the clip begins, BEN is jumping
forward, responding to a question. He is intense – an advocate.

BEN: (*On TV.*) Here's what we know. We *know* that in the
months after 9-11 the Attorney General, at that time
White House Counsel, wrote a memo to the President
and his cabinet describing the Geneva Convention as
being outdated…and quaint. We *know* that in the weeks
immediately following that, another man, the Assistant
Attorney General, wrote another memo, this one defining
torture as only those acts that lead to such things as organ
failure. All other acts, he said, even those acts he might
allow…constituted cruel, inhuman, or degrading treatment
do not 'rise to the level of torture'.

HOST: (*V.O.*) Unbelievable.

BEN: (*On TV.*) We *know* that the United States while gearing up
its own detention system began using the detention systems
of others.

HOST: (*V.O.*) The rendition program.

BEN: (*On TV.*) The rendition program, yes. And that among
those to whom we subcontracted our prisoners were such
countries as Uzbekistan, Syria, and Morocco. Uzbekistan,
run by a man named Karimov, is known to have boiled
some of its prisoners alive. Syria makes use of what they
call 'the German Chair'…a metal frame given to them by
the East German secret police, the Stasi, that can literally
break a man's back. Morocco, according to a reporter from
the *London Times*, is said to have two favored techniques.
One involves razor blades used to inflict tiny cuts all over
a man's body. The other involves a glass bottle. With
this technique, the prisoner is forced to break the bottle
and then sit on it, thereby raping himself. These are the
countries we're doing business with. This we *know*.

HOST: (*V.O.*) Incredible.

BEN: (*On TV.*) And that's not the half of it.

HOST: (*V.O.*) (*Agreeing.*) Oh, God, no.

BEN: (*On TV.*) We *also* know that…

The lights come up on JUDY and ROGER the two facing out at the audience. JUDY is at home, ROGER: is at the courthouse.

Their conversation is anxious. It is later that day.

ROGER: So far nothing.

JUDY: Nothing, he hasn't gone in?

ROGER: Nothing, he hasn't come out.

JUDY: Which means what?

ROGER: It means it's good. If it was bad, he'd come out.

JUDY: How long's he been in?

ROGER: An hour, an hour and a half.

JUDY: And he hasn't come out yet?

ROGER: No.

JUDY: And –

ROGER: Hang on, wait a second.

JUDY: What is it?

ROGER: (*Listening.*) I thought I heard something.

JUDY: Heard something…where?

ROGER: Outside.

JUDY: Outside where?

ROGER: In the hallway.

He opens a door, looking out.

They got me in the back end of the building, in a room here. I have no idea where I am. I have to listen.

JUDY: (*Beat.*) And?

ROGER: And... (*Then, in response to something said in the distance.*) Say what? (*He listens, covering the phone.*) Look, I'm... (*Something else is said.*) Look, I'm not in *jail* here. I got... (*Then, again something is said.*) Hey, *you're* a fucker! Okay? I'm a fucker, *you're* a fucker. (*With that, he quickly closes the door, muttering.*) Asshole.

 Beat.

JUDY: (*Worried, incredulous.*) What was that?

ROGER: Nothing.

JUDY: Who were you talking to?

ROGER: No one.

JUDY: (*Losing it.*) Roger, what is going *on*?

ROGER: Nothing!

JUDY: (*Irate, incredulous.*) 'You're a fucker'???

ROGER: (*Long beat, ashamed.*) It's tense.

 Beat.

JUDY: (*Abrupt.*) I'm coming down.

ROGER: Judy, no.

JUDY: Roger, I should be there.

ROGER: No, you shouldn't.

JUDY: Rog –

ROGER: Judy, this is the reason I'm calling you. To keep you informed. Not to have you come down here. That would only make it worse.

JUDY: (*Dry.*) Thanks.

ROGER: (*By way of apology.*) We don't need to make it any more tense.

Beat.

JUDY: So you didn't go in till eleven?

ROGER: A little after. (*Then, correcting himself.*) Eleven, yeah.

JUDY: And now it's almost twelve-thirty.

ROGER: I'm surprised they didn't take lunch.

JUDY: Is that unusual?

ROGER: It…well, yeah, as I say, I'm surprised by it.

JUDY: What does it mean?

ROGER: Judy, I don't KNOW. I…look, I don't know what's going on. I just wanted you to know that nothing bad is happening.

JUDY: Nothing bad *has* happened. You don't really know what's going on now.

ROGER: Right.

JUDY: Okay, look –

ROGER: Wait a minute.

JUDY: (*Anxious.*) What?

ROGER: I heard something.

JUDY: What?

ROGER: Footsteps. In the hall. (*Getting excited.*) I think he's coming.

JUDY: Roger.

ROGER: (*More excited.*) I'll call you back. When I know more, I'll call you back!

Suddenly ROGER turns, and just as he does so, BEN enters. He is wild-eyed. Instantly the door closes behind him.

(*Anxious.*) What's going on?

BEN: I'm fucked.

ROGER: What do you mean?

BEN: I'm fucked!

ROGER: Ben, what are you talking about?

BEN: He didn't stick to the script.

ROGER: What did he say? What did he ask?

BEN: About the meeting with McDonald.

ROGER: What about it?

BEN: Who else was there.

ROGER: (*Beat, nervous.*) And what did you tell him?

BEN: Sofer.

ROGER: You told him Sofer was there?

BEN: Yes.

ROGER: You mentioned Sofer's name!!

BEN: Yes. (*Fumbling.*) I… (*Then, finally.*) Yes.

ROGER: (*Beat, confused.*) Why the hell did you do that?

BEN: (*Genuinely baffled.*) I don't know.

 Beat.

ROGER: And so then what?

BEN: Well, that opened up everything. He wanted more names and dates.

ROGER: And you came out to find me.

BEN: No.

ROGER: (*Surprised.*) No?

BEN: I gave him some.

ROGER: You *gave* him some???

BEN: He wouldn't let me leave otherwise.

ROGER: Ben, he's gotta let you leave.

BEN: He wouldn't. He –

ROGER: Ben, I told you, you have merely to say I want to consult counsel.

BEN: I said that!

ROGER: And he said no?

BEN: He asked the foreperson if that would be okay.

ROGER: (*Incredulous.*) He asked the foreperson???

BEN: The lady there, yes. (*Shouting, exasperated.*) The foreperson. The lady!

ROGER: He's got the foreperson at the desk there?

BEN: At the table, yes.

ROGER: And he's using her to… And she said no.

BEN: She thought a couple more questions were in order, she said. The line we were on.

ROGER: And so he asked…what did he ask you?

BEN: The first time I met him.

ROGER: Sofer.

BEN: Yes.

ROGER: And you said?

BEN: December. Actually, I said I wasn't sure…but I thought it was December.

ROGER: And is that right? Was it?

BEN: Yes. I think so.

ROGER: And then what?

BEN: What we talked about. Where was it. You know. Everything.

ROGER: And what did you tell him.

BEN: That's when I said I wanted to come find you.

ROGER: But he didn't let you.

BEN: No.

ROGER: So what did you say?

BEN: The war. Just generally I said the war. And I didn't know where. I didn't remember.

ROGER: But he didn't let you get away with that.

BEN: No.

ROGER: So what did he say?

BEN: He backtracked. He went back to McDonald.

ROGER: And how much did he know about him?

BEN: A lot. I don't know where he got it, but he knows McDonald helped me with Bagram. He knows he helped with the jets. He knows…you know, he knows he's disgruntled. He knows a lot.

ROGER: And now he puts you and him with Sofer.

BEN: Right.

Beat.

ROGER: And so you left on what grounds? What were you… what do you need to ask me?

BEN: How the fuck I can leave this shit. How I can get out of there.

ROGER: You can't.

BEN: Roger, I can't do any more. I can't give any more up.

ROGER: Then you're going to prison.

BEN: What the hell do you mean? I talked to them!

ROGER: Yeah, but you don't get to say 'enough'. You don't get to say 'I'm done'. When you start talking, you gotta keep talking. *They* say when you're done.

BEN stares at him a moment, then turns away.

BEN: This is so bad.

ROGER: I can't believe you mentioned Sofer's name.

BEN: (*Angry, afraid.*) Roger, he knows a lot.

Beat.

ROGER: Is Sofer the guy?

BEN: What?

ROGER: Is Sofer the guy? Is that where you got the order from?

BEN: (*Aghast.*) I can't tell you that.

ROGER: Ben, at this point, why not? What…who cares??

BEN: Roger, I can't tell you that!

ROGER: Ben, look, if you want me to help you… I mean, we're in a whole new game here. Protecting sources? We're past that now. We're looking at contempt minimum. And we could be looking at a lot worse.

Beat.

BEN: (*Agitated.*) They bring him out…my source? He knows I gave him up. (*Growing angrier.*) I give him up, he talks. He SAYS I gave him up. I get outed. You think I work again? You think somebody hires me?

ROGER: (*Nearly mocking.*) Guy who won the Pulitzer? Guy at the center of a story like this? Yeah.

BEN: (*Shaking his head.*) No.

There is a knock at the door.

ROGER: (*Shouting, angry.*) Few minutes!

BEN: Roger, no. I am a pariah. I don't work at a J school. (*This last he says derisively, dripping contempt.*) I don't support my family.

Beat.

ROGER: So what are you going to do?

BEN: That's what I'm asking you. I gotta get out of here.

ROGER: I don't see how. I mean, you want, we talk to the judge. We tell him the agreement, we tell him he overshot… (*Slight beat.*) …but I'm telling you, you opened the door. You mentioned Sofer, you gotta talk about Sofer. In fact, at the moment, I don't even know what the agreement is.

BEN: The agreement is I talk about McDonald. A mid-level guy. A guy I have a relationship with. That I went to college with. That gave me authorization to talk about the meetings that I had with him. That's the agreement.

ROGER: But you broke it. Right? Did you break it? (*Slight pause.*) Did you bring up Sofer or did he?

BEN: (*Bit desperate.*) I don't know. I don't know, I… I don't know.

ROGER: It's possible he did?

BEN: I think.

ROGER: Well, THINK, Ben! How did it come up?

BEN: (*Searching.*) I…

ROGER: He –

There is another knock.

(*Shouting.*) A few fucking minutes! (*Then, back to BEN.*) He is asking about McDonald.

BEN: Yes.

ROGER: He wants dates of meetings.

BEN: Yeah.

ROGER: How many were there, by the way?

BEN: (*Shaking his head.*) I don't know, three…four, five.

ROGER: You don't KNOW? Is that what you told him?

BEN: I have notes about three. I remember another…one or two. Brief. Passing. In the building stuff. There to see other people. Altogether I would say five.

ROGER: But three that were arranged, three where you went to him.

BEN: Yes.

ROGER: And that's what you discussed.

BEN: Yes.

ROGER: And –

BEN: And he wanted to know who was in the room. One of these meetings, he stops me, he says, 'who else was in the room?' And I didn't know what to do.

ROGER: And that's when you asked to see me.

BEN: That's one of the times.

ROGER: (*Surprised.*) You asked more than once?

BEN: I asked three times.

ROGER: (*Outraged.*) You asked three times???

BEN: Yes.

ROGER: You asked three times to see your counsel and he didn't let you?

BEN: Each time he turned to the bailiff –

ROGER: The forelady –

BEN: The forelady –

ROGER: And she said no.

BEN: She said soon, or not yet, or I think we need to finish this.

ROGER: Like it was prearranged.

BEN: Yeah. She wasn't letting me out of there. And it wasn't really a question.

ROGER: Well, that alone I think… I mean, that alone… (*His mind is working.*) …I think we tell that to the judge, that… I mean, I'm not sure it gets you anything more than a delay. But I think we can get you out of here today. I mean, there is no… (*Still almost thinking to himself.*) …you have a right to counsel. And they have to be reasonable. And three times… (*He turns to BEN.*) I think we can get you out.

BEN: (*Nodding.*) I can't do any more.

ROGER goes to the door and knocks on it. It opens. We don't see who's there.

ROGER: Bailiff. We want to see the judge. Part One.

The door closes.

(*Turning back to BEN.*) I don't think it buys you anything more than a delay.

BEN looks at him, haggard.

There is a long, long pause.

Who else was there?

BEN: What?

ROGER: When you met with Sofer? The first time?

BEN stares at him a long moment.

BEN: You don't want to know.

Beat.

ROGER: Name I'd recognize?

BEN: (*Very dry.*) Uh...yeah.

ROGER: And so that's part of this, huh? Where else this leads?

BEN: Yeah.

ROGER nods.

ROGER: (*Then.*) Well, like I say –

A knock. ROGER goes to the door, has a conversation with the offstage bailiff, we see him alone nodding his head. And again the door closes. Once it does, ROGER turns back to BEN.

He's at lunch. We'll see him after. (*Beat.*) You want to get a sandwich?

And BEN nods.

Okay, let's go. There's a place around the corner. I think –

But before he can finish, the lights black out.

Again the lights come up on the television – where again we pick up BEN's interview.

BEN: (*On TV. On a roll, mid-thought.*) We *also* know that at some point our government became impatient. That despite the use of the techniques these governments used, we were not getting the kind of information we wanted. And so we started building our own network...and asking for permission to conduct what we called 'enhanced interrogations.' These interrogations took place in a series of prisons, some known, some secret. The known prisons

included Guantanamo, Bagram...others in Afghanistan, smaller prisons, and a few in Iraq; the airport. The secret prisons we're just finding out about. My report, following another written a few months earlier by the *Washington Post*, concerns these.

HOST: (*V.O.*) And what have you learned?

BEN: (*On screen.*) Among other things, that innocent people have been killed. And they've been killed intentionally – as part of a program to extract information. We have found at least two instances where civilians were brought into the cells of what are known as 'high value targets' and executed. Simply to alarm.

Once again the lights come up on JUDY and ROGER. This time their exchange is rapid, angry – exasperated.

ROGER: Judy, I don't *know*!

JUDY: He left at 1? 2?

ROGER: Two. A little after 2. 2:30.

JUDY: You just put him in a cab?

ROGER: He said he wanted to be left alone.

JUDY: And where did you go?

ROGER: I stayed.

JUDY: Till when?

ROGER: Till now.

JUDY: (*Incredulous.*) You're still there?

ROGER: Yes, Judy, I – !

JUDY: Doing what, Roger???

ROGER: My job, Judy!

JUDY: And what is that, Roger, talking to the prosecutor? Huh? Cutting a deal? How many years is my husband going to get?

ROGER: Judy, what do you want me to do?

JUDY: How 'bout checking on your client? How's that sound? How 'bout checking on where your fucking client has been since two in the afternoon?

ROGER: Do you want me to call the police?

JUDY: (*Mocking.*) Huh? Do you think?

ROGER: Who do you want me to call? DC? Maryland?

JUDY: APB, motherfucker!

ROGER: Judy –

JUDY: Roger, it is ten in the evening. (*Nearly hysterical.*) It is ten goddamed o'clock! Okay!?! ? (*Suddenly near tears.*) And I want to know where he is.

ROGER: Judy, he's fine.

JUDY: (*About to burst into sobs.*) I want to know where he is.

BEN: Right here.

This last comes from BEN, who appears from behind her. He is in the shadows, his voice low, quiet, a little slurred.

I'm right here. (*Then, after another moment.*) I'm right here.

At this there is a long, LONG pause – as JUDY turns around and simply stares at him.

ROGER: (*Confused by the silence.*) Judy?

JUDY: (*Empty.*) He's here.

ROGER: What?

JUDY: (*Beat.*) He's here.

At this, the lights go out on ROGER, and there is another long pause.

(*Finally.*) What the hell, Ben?

Another pause.

Ben, what the hell?

She comes over to him. He is not moving.

Are you all right?

He takes a moment, but then nods.

Where have you been?

He doesn't answer.

Ben, where have you been???

BEN: (*Finally.*) I just… (*But he can't finish.*)

JUDY: Do you know what time it is?

BEN: Ten.

JUDY: Ten. Yeah. (*Beat.*) It's ten. (*Her voice has remained quiet – though she is clearly quite tense. Baffled. Angry. And at the same time concerned.*)

BEN: I'm sorry.

JUDY: (*Quiet.*) Where have you been? (*BEN shakes his head.*)

BEN: I… (*Struggling.*) …I just… (*Another moment of struggle.*) …I had to be alone.

JUDY: And so you left the courthouse and went where? (*He looks up at her – his eyes asking her to please stop. She can't.*)

Have you been drinking? (*He doesn't answer.*)

Have you been at a bar drinking?

Long pause.

BEN: (*Finally.*) Yeah.

She stares at him. A trace disgusted? Then…

JUDY: Well, come upstairs now.

BEN: No.

JUDY: Ben, come upstairs. What are you going to do, stay down here?

BEN: I just…

JUDY: (*Beat.*) Did you have anything to eat?

BEN: Yeah…

JUDY: (*Suddenly, blurting.*) Ben, where have you been! I mean, you weren't in a bar for seven hours.

BEN: Eight.

JUDY: Where have you been?

But again BEN can't answer her.

Do you know how worried we were? (*Then, correcting that.*) I was. I don't think Roger gives a damn. Do you know how worried I was?

BEN: I'm sorry.

JUDY: You're sorry?? (*Then, after another moment, knowing how tough it's been.*) What happened? I mean, I didn't really learn anything from Roger. What happened?

BEN: I made a mistake.

JUDY: What? (*As in 'what kind?'*)

BEN: I talked about something I shouldn't have.

JUDY: How is that a mistake? How… Don't you have to do what they tell you to?

BEN: We had an agreement. That I could…testify about one thing, one meeting…one set of meetings…and that would be enough.

JUDY: And what happened?

BEN: I talked about something else.

Long pause.

JUDY: Well, I'm sure you did what you had to.

BEN: No. (*Beat.*) I did what I wanted to.

JUDY: What do you mean?

BEN: I wanted to give them this. I'm starting to think I wanted to give them this.

JUDY: Ben –

BEN: I didn't have to say it Judy. I could have sat… I mean, Roger prepared me. I could have sat there…could have… and there was no way they could have gotten it. But for some reason that's not what happened.

JUDY: (*With empathy.*) You were scared. Right? I'm sure you were scared. And there's no way you can help that.

BEN: He keeps saying…you know what he's saying the whole time… the prosecutor…that our nation is at war. That with our nation at war…*surely* with our nation at war…with an enemy so cunning, so difficult to recognize…with the kind of weapons he may be able to get his hands on…surely in *that* circumstance…I might want to consider my responsibilities as citizen…before I invoke my privileges as a journalist.

JUDY: (*Beat.*) Right.

BEN: Right?

JUDY: Right, I…(*Struggling.*) …right.

BEN: You agree. (*It isn't a question.*)

JUDY: I –

BEN: Because I'm starting to think maybe I do. You Know? (*Beat, turning inward.*) I'm starting to think maybe I do.

JUDY: Ben –

BEN: And I wasn't alone, Judy. Everyone in that room – there were 15, 18 people in that room…citizens…all of them looking at me…just…disgusted. Like I was the traitor.

JUDY: Look –

BEN: (*Suddenly loud.*) WHO THE FUCK *AM* I? You know? Am I putting our country at risk? When I just cavalierly…

He stops, near tears.

JUDY: You don't cavalierly do anything.

BEN: Oh yes, I do. Oh yes, I do. Or if it isn't cavalier, it certainly isn't considering… I'm certainly not considering the country. I'm just thinking about the story. That I got a story. That I got a story *so big…*

Again he stops himself, blinking tears, disgusted at his pride.

JUDY: Ben, you're confusing things. (*Beat.*) Your story. Which have every right to tell. And…

Pause.

BEN: And?

JUDY: And the thing you have to do when they ask you. (*Beat, gentle.*) You have to give up your source. (*Beat.*) But that doesn't mean…I mean, that doesn't mean… (*She tries a different tack.*) We each have a job to do. You've told me this a million times. We each have a job to do. A defense attorney, a defense attorney defending a murderer…does so for us. So that we can live with ourselves. So that if we put that murderer to death…we will know we did so fairly, that he had a defense. 'How the hell can you defend that man?' 'So that you people can live with yourselves.' (*She looks at him – he is clearly distraught.*) Your job is to get the story. You did nothing wrong in –

BEN: Well, we're past that. Okay? We're past that! (*Picking up steam.*) I got the fucking story. I printed the fucking story. And in doing so, at least if you listen to some of them… I have made our country less safe.

JUDY: That's… (*Taking a moment.*) …do you believe that?

BEN: I don't know. (*He considers this a moment, truly confused.*) I don't know.

Another pause.

JUDY: Well, I don't believe that.

BEN: Al-Qaeda hates us, Judy.

JUDY: They hated us before. They'll hate us after. What you said doesn't make them hate us more.

BEN: No?

JUDY: No.

BEN: (*Suddenly, a small laugh.*) Of course, you know the irony of this. If I didn't write that…other…that…'let's shake 'em a little, let's slap 'em a bit', none of this happens. You know? That other column.

He stands, going over to a cabinet, removing a bottle.

If I didn't leave the reservation, didn't have a momentary…deviation…from the party line… (*This last he spits out bitterly.*) …believe me, I am not let out to dry. I mean, those…you cannot… (*Spluttering with anger.*) And look, I'm not defending it. I'm not saying I was right. I was wrong. But you cannot tell me…that that other column isn't connected to this. You know? (*Slight beat.*) Don't you agree?

By now he is drinking.

JUDY: (*Tight.*) I don't know.

Beat. He smiles at her, smug.

38

BEN: You don't forgive me, do you?

JUDY: Let's… (*About to say 'not go into this', she instead lets it drop.*) …

Beat.

BEN: Do you?

JUDY: (*Tighter still, grudging.*) I understand why you wrote what you did.

BEN: But you don't forgive me.

JUDY: Ben…go to bed.

BEN: Can you tell me that? Why can't you just tell me that?

JUDY: I wish you hadn't written it. I don't think it was *smart* for a reporter to write a positive op-ed on torture! But do I think it has to do with why you're in court now? With this investigation? (*Beat.*) No.

BEN: You think the intelligentsia, you think the *New York Times*…lets me twist in the wind like this I don't write that column?

JUDY: I don't think the one has anything to do with the other.

BEN: Well then you don't know the first thing about the way my world works.

JUDY: (*Beat, stung.*) Well then I don't know the first thing.

Beat.

BEN: And I'll tell you something, I wouldn't print it, but I still believe what I said. We are dealing with monsters. With sociopaths. And there is no governing…you know, al-Qaeda doesn't have a government over them. They can't be 'reined in'. And so the rules of the game have changed. Or if they haven't changed, they will. Twenty years from now, thirty years from now…because we're going to be at war with al-Qaeda *forever*…you're not going to be able to recognize this place. And the U.S. will do what the

U.S. needs to do. If we have to pull fingernails, we will pull fingernails. Believe me. (*Beat.*) So in the meantime, to start with, if it prevents that…if we can do things, you know, whatever, the noise shit…the stress positions…sleep deprivation…if we can do things that KEEP us…from doing the other…I still don't think that's wrong.

Beat.

JUDY: (*A trace bitter.*) Then why not write it? If that's what you believe, why not write it?

Pause. BEN is stumped, shamed.

BEN: Because it's suicide for me to write it. Because when I *did* write it, people looked at me like I'd grown a third head. Like I was a Klansman. Like I had lost…whatever…you know…

He stops, the pain again overwhelming.

(*Then, after a long moment:*) It's called getting ahead of the curve. I'm ahead of the curve. We have another attack, another 9-11…you'll get fired from your paper you *don't* write that column. But right now…?

Slight pause.

JUDY: You have told me you consider that column the great mistake of your life. Haven't you said that?

BEN stares out for a long moment, blinking away tears, shaking his head.

And the irony… I mean, you used the word irony, there are people who think this story, the one you're in court about now, is a direct *result* of writing that column. That you are writing today about rendition, about black sites, about secret torture cells…*because* you wrote so approvingly earlier. Isn't that true?

Pause.

BEN: That's why I'm writing it? Or that's what people say?

JUDY: Both.

Beat.

BEN: I know that's what people say.

Beat.

JUDY: Is that why you're writing it?

BEN: (*Hesitant.*) No, I… (*Struggling.*) No… (*Another beat.*) No, that –

The phone rings. But JUDY is unmoving, staring at BEN. Till the phone rings again. And finally she goes to it. She listens. Then…

JUDY: It's Roger.

But BEN doesn't move.

Ben, it's Roger. (*To ROGER.*) Hang on. (*Then, back to BEN.*) Ben, it's Roger. He wants to talk to you.

But still BEN doesn't move. He is lost in thought.

Ben!

BEN: (*Finally.*) Do you still love me?

JUDY: What?

He looks up at her.

BEN: Do you still love me?

JUDY: (*Beat, confused.*) Yes, of course –

BEN: (*Suddenly screaming.*) Do you still fucking love me, Judy!

JUDY: (*Screaming back.*) Yes, Ben, I still fucking love you! (*Beat.*)

BEN: Why?

JUDY: What?

BEN: Because I'm your husband? Or because I'm the father of your children?

JUDY: Ben –

BEN: (*Loud.*) I'll call him back! Tell him I'll goddam call him back!

JUDY: (*Beat, into phone.*) He'll call you back. (*She then hangs up, turning back to BEN.*)

BEN: Do you still love me as your husband?

JUDY: Yes.

BEN: Are you sure?

JUDY: Ben, why are you asking me that?

BEN: Because I'm not sure I would if I were in your shoes.

JUDY: (*Beat.*) Well, I do.

BEN: I mean, we just…you know, we go through year… (*Disassociating.*) But then these last years, these –

JUDY: Ben, I still love you.

BEN: Why?

JUDY: Because you make me!

This last she tries as a joke…but when he doesn't laugh…

Because…you care…deeply…about all of this. As you care deeply about me. And our kids. And I don't think I could find someone else who would care as much.

He stares at her.

BEN: I… I didn't make a mistake, did I?

JUDY: Yes, Ben, you did. But we all make mistakes. And you, unlike most people, work to fix your mistakes. To acknowledge your mistakes and to fix them. That's another reason I love you.

BEN: I feel… (*He takes a pause.*) …I was going to say something else, but you know what I really feel? Lucky. (*Suddenly he pulls her to him, hugging her close.*) Lucky to have you.

JUDY: (*Beat.*) Ben, I love you. And I'm not alone. There are many people who love you. Truly. And are pulling for you. And… Roger. Roger loves you.

BEN: Say what?

JUDY: Roger loves you.

BEN: What you're sold on Roger now?

JUDY: Yeah. (*Beat.*) I am.

BEN stares at her a moment, evaluating.

BEN: Well don't be.

JUDY: What do you mean?

BEN: Just don't be.

This last he says with an edge.

JUDY: Ben –

BEN: I don't trust him.

Beat.

JUDY: (*Thrown.*) Ben, what are you talking about?

BEN: I don't… I don't know, I just… I don't know.

JUDY: Ben, look…you're having an understandable…but Roger is there for you. Really. Maybe…and I know it isn't what i said this morning…and maybe it's just 'instinct' on my part…(*Beat.*) but I know he is.

BEN: You sure?

JUDY: Yeah.

BEN: (*Beat.*) Okay. (*Then, after a moment.*) Okay. Let me call him.

JUDY: Okay. But –

BEN: (*Urgent.*) Let me call him!

JUDY: Okay –

*But before JUDY can finish the word 'okay', BEN has turned out,
ROGER appearing across from him, the two engaged in a conversation
that is immediately abrupt, staccato-like, almost hostile.*

BEN: Yeah?

ROGER: (*Accusing.*) What did you do?

BEN: What?

ROGER: The people around here are pissed, Ben.

BEN: You're still down there?

ROGER: Yes.

BEN: Doing what?

ROGER: Trying to keep your ass out of jail! Now, tell me, Ben.
What did you do, where did you go? Who did you talk to?

BEN: No one. I was alone.

ROGER: For seven hours!

BEN: Roger, what the fuck?

ROGER: What the fuck what, Ben?

BEN: Are you grilling me here?

ROGER: I'm trying to get the truth out of you, Ben. I don't
know how to represent you if I don't know the truth. Now
tell me the fucking truth.

BEN: On the phone? Right now? I don't think so.

*This last an allusion to the fact that the phones are undoubtedly
bugged.*

ROGER: Well then tomorrow, morning, at nine o'clock. They want you here at ten, you come at nine. Okay?

Beat.

BEN: Yeah.

Beat.

ROGER: And Ben, I'm serious. You gotta help me with this.

BEN: What's going on?

ROGER: What?

BEN: What am I facing here?

ROGER: What kind of sentence?

BEN: Yeah.

ROGER: Depends on the crime. For Espionage? Tw…(*Beat.*) Actually, let's not get into it now. Let's just say it depends on the crime.

Pause.

BEN: I'll see you.

ROGER: Ben!

BEN: What?

ROGER: You were with that girl?

BEN: What?

ROGER: That girl. Ben, you know what I'm talking about. Is that where you were?

BEN: No, Roger. That's… (*Slight beat.*)…no. (*Then:*) No.

ROGER: (*Beat.*) Okay.

With that BEN hangs up, the lights going out on ROGER.

JUDY: What did he say?

BEN: They want me there at ten.

JUDY: What are you facing?

BEN: Depends on the crime. (*Long pause.*) But it doesn't sound good.

Beat.

JUDY: (*Then, frightened.*) Ben, listen to me. Don't be a hero. Okay? You've done a lot already. (*Beat.*) Don't be a hero.

BEN and JUDY stare at each other – when suddenly we shift back to the TV.

HOST: (*V.O.*) Of course, I would be remiss if I didn't bring up that column you wrote in late fall 2001 –

BEN: The torture column.

HOST: (*V.O.*) The torture column, yes. The so-called torture column. Just to remind our viewers, you echoed in that writing what another columnist had said some weeks earlier. That our attitude toward torture was…naïve I think you said. That we had to be prepared, I believe your word was, to use methods we hadn't used heretofore. (*Beat.*) Is that correct?

BEN: (*Uncomfortable, half-nodding.*) That's… I could quibble. But that's substantially correct.

HOST: (*V.O.*) And –

BEN: And as the other columnist said about *his* column… I consider that column to be among the great mistakes of my career. If not *the* greatest.

HOST: (*V.O.*) But is it fair

BEN: (*Harsh.*) No! It is not! (*Then, continuing, sheepish.*) Excuse me. It's just I thought you were about to ask if it's fair to lump the two. To suggest that my current writing, my current story is in some way connected to that opinion.

HOST: (*V.O.*) That's…yes…that's…what I was –

BEN: And I'd say no. It is not. (*Beat.*) It is not fair. They are not at *all* connected to each other.

HOST: (*V.O.*) I see. (*Beat.*) Well, let me ask you this then. Connected or no…do you think it had an effect? Do you think, as some people suggest, that it opened the door to this administration's policies? That without you, and people like you – Alter, Krauthammer, Dershowitz…that whole *wave* of people writing about torture – that without you the administration would not have had as easy a time *implementing* its policy? (*Beat.*) Do you, in short…feel complicit?

BEN: (*Stunned.*) That's…no, that's…

He stops a moment, gathering himself.

No, I don't think it's fair to say a journalist, even one…that he shares equal responsibility with the government, no.

HOST: (*V.O.*) I didn't say 'equal' responsibility. I said…or implied…*some* responsibility.

Pause.

Do you feel you bear 'some' responsibility? Those memos, for instance, the ones you cited earlier, the organ failure, the dismissal of Geneva as 'quaint'… those memos *followed* your writing. (*Beat.*) Don't you think it had an influence?

Pause.

BEN: (*Pained, halting.*) Perhaps. (*Beat.*) Some.

HOST: (*V.O.*) Because I certainly do. (*Beat, unforgivingly.*) Forgive me, but I certainly do. (*Beat, lighter.*) Still, not to belabor the point, let's move on. Actually, before we do, perhaps we should take a break. We'll be right back…with our guest…Benjamin Kritzer. Prize-winning journalist. (*Beat.*) Discussing his article on America and its –

Blackout.

47

Lights up on the scene from the beginning, the man in the hood sitting bolt upright behind the washbasin. The man in the ski mask is now standing behind him, his hand on the water spigot. He turns off the tap, and we hear the squeak of the water as it stops running. The man in the ski mask then removes the hose from the basin and drops it to the floor. He then picks up a long, soiled hand towel and lowers it into the water.

As he does this the hooded man remains unmoving, though clearly quite terrified. Suddenly the man in the ski mask flicks water from the towel onto the man's legs – and instantly the man in the hood flinches.

The man in the ski mask then starts to twine the towel into a rope.

Blackout.

End Act One.

Act Two

Lights up on JUDY, facing out. She is on the phone and she is exasperated, angry.

JUDY: Mom. Mom! (*Beat.*) Please! I do not know anything more than I told you. He is not…as far as I know he is not in danger. He is…they want him for questioning. (*She listens, nodding.*) Right, yes, because…because he wrote that story, yes. (*She listens.*) That's what they say, yes. (*Then:*) No, I do *not* agree! It is not disloyal to write that story! That is the function of… (*Talking over her mother.*) …that is the *function* of journalism. We *need* that story to be written. Mom. Mom! (*She is cutting her off.*) Look, I can't talk to you anymore about this. Right now. Okay? (*Beat.*) I…(*She listens.*) …they're fine. No, they're both fine, they're… Thank you. If I need to, I will. I promise. (*Again she is listening.*) Okay. Okay, thanks. Okay. Okay, I will. I love you too. Right. Goodbye. (*She hangs up. And immediately she dials again.*) I need you to do me a favor. I need you to go over to mom's. (*Beat.*) She just called. She…she's melting down. (*She listens.*) I didn't know what to say to her. What could I say? My husband's an asshole? (*Beat.*) Hell, yes, that's what she wants me to say. That's what she's wanted me to say for twenty years, why should today be different? She is sitting there… I can hear her…she is sitting there *praying* that he gets indicted. (*Then, backing down from the statement.*) All right, that's… All right, look, we don't need to replay the last twenty years. Suffice it… Look, I don't want her calling me anymore. Okay? Can you just help me with this? (*Beat, she listens.*) I don't know. (*Beat.*) I don't know, the prosecutor's an ass, he's breaking every kind of rule. He's… (*She listens, then.*) So I don't know. (*Beat.*) Like shit. Like I don't know what's going to happen to my life. I mean, Jesus, Dave, my husband goes to jail? What the fuck? What am I supposed to do? Am I in the mafia? Do I go to the Don? What do I do? (*Long pause, listening, talking*

about money.) Some. (*Beat.*) Thank you. (*Beat.*) Like shit. I haven't taken a photograph in three months. That gallery in Baltimore, I don't know what's happening with them. I can barely follow up. I… (*Beat.*) It's taken the oxygen out of the room. (*Then:*) You know? It's taken all the oxygen out of the room. It's like my life is on hold. But I… I want to be there for him. I *have* to be there for him. I mean, my fucking family. I… (*Suddenly near tears.*) But I did not bargain for this. You know? (*Her face crumbling.*) I did not fucking bargain for this. I did not ask for a husband with a fucking narcissistic complex who feels like he's the only one capable of saving the world. (*Suddenly adding.*) When he isn't electrocuting the world. When he isn't fucking torturing the world. (*She stops herself, holding her head, in great pain, sobbing. Then, after a long time:*) Look, I gotta stop. I… (*Beat.*) No, it's going to be all right. I know. (*Beat.*) I know. No, you're right. No, I'm fine. I'm fine. Just look in on mom will you? (*Beat.*) Thanks. Thanks… Yeah. (*Beat.*) Thanks.

Suddenly the lights switch to ROGER and BEN. They are in the midst of it, already arguing, both of them on edge. It is the next morning.

ROGER: That's not the point.

BEN: Of course it

ROGER: He thinks you lied!

BEN: How so?

ROGER: He wouldn't say. It's secret testimony, he said. It's privileged. He –

BEN: Well, that's bullshit!

ROGER: But *because* you lied… (*He stops, wanting to make sure that BEN is paying attention.*) …and because you opened the door…the agreement is void. (*Slight beat.*) There *is* no agreement.

BEN: Which means what?

ROGER: It means the last two months is down the drain. It's like I never talked to him. You're a regular Grand Jury witness. Actually, I should amend that. You're a regular Grand Jury witness who has committed perjury.

At this, BEN shifts in his seat, becoming unsettled.

BEN: And so what are… (*More unsettled.*) …what are the options?

ROGER: Go to jail. Or don't go to jail.

BEN: How do I stay out of jail?

ROGER: By telling him *everything* he wants to know.

Pause. The walls are closing in.

BEN: (*After a moment, impulsively.*) I want to talk to the judge.

ROGER: And say what?

BEN: Tell him about the agreement. Tell him –

ROGER: Ben, I told him. That's what I've been talking to him about.

BEN: And what did he say?

ROGER: It's not in writing. For starters. It's not…and it's he said/she said. The prosecutor doesn't agree that he's abrogated a thing. But Ben, look, the truth? It doesn't matter. The prosecutor can get you in that room ask you whatever the fuck he wants. There is no agreement that can protect you.

BEN: Then why did… (*Losing it suddenly, angry.*) …what the fuck did we do here???

ROGER: We tried.

BEN: Tried what?

ROGER: To see if…you know, if we could persuade him to have some rules.

BEN: What???

ROGER: Ben, that's all it was. *Persuading* him. He doesn't have to do shit. There is no…we tried to get him to balance the needs of justice with protecting the first amendment. But he doesn't have to do that. He is not *obligated* to do that. He is OBLIGATED to pursue justice. And in his mind justice is finding the leak. And closing the leak.

BEN: (*Agitated, angry, yet full of himself.*) Do you realize what happens I give him my source? Do you understand what happens?

ROGER: (*Understated, it's his life's work.*) I think so.

BEN: There are no checks. Right? There are NO CHECKS. Because let's not make any mistake about this. Congress is not checking on this. I don't give a shit what elections there are. I don't care WHO is in power. We have a President who says our nation's SECURITY hinges on this. That it is Un-American…to look into this…there is no Congressional committee in existence that will cross him. After we've been attacked??? (*He shakes his head.*) And so you've got unchecked power. Okay? *Unchecked* power. And the one thing that stops this…the *one thing*…is people like me. The fourth estate. The fact that he may get embarrassed. The fact that our populace the next time they go to vote may vote as informed citizens…that's the one thing that stops him. And I cannot write, I cannot *do my job*…if I am not talking to people. If people are not talking to me. If they are afraid to talk to me. If they think I'm going to give them up. They will not talk. And I will not have a story to tell. And what is happening right now…what is happening every fucking day, in our name…affecting the way our country will be seen for *centuries*…will continue happening without us even knowing about it. (*A beat.*) What we're talking about is *informed* consent. That's the way our Constitution, our Democracy, is designed to work. And we don't have informed consent…if we don't have an informed populace…

ROGER: Ben… (*Shaking his head.*) …who are you talking to?

BEN: I'm just saying, I have a job to do. There is something at stake here.

ROGER: I understand.

BEN: So –

ROGER: But BEN!

He takes a moment – having shouted – this last getting BEN's attention.

You can still do your job. You're not giving public testimony here. This is not open court. You tell him what he wants to know…and you walk out.

BEN: And they go get my guy, and they handcuff him, and they frog-march him out of the building and do you know what comes next?

ROGER: I –

BEN: He puts his finger on me! Roger! He tells the world I gave him up. I mean, what the fuck???

ROGER: So what do you want to do?

BEN: I want to wall off the questions.

ROGER: What do you mean?

BEN: Questions I'll answer/questions I won't.

ROGER: Ben, I told you, no agreement.

BEN: No yesterday agreement. Maybe there's a today agreement.

ROGER: What do you mean?

BEN: We give him some, not *all*, of what he wants. Something he can't get anywhere else. And maybe he figures out another way to get the rest.

ROGER: (*Beat.*) What are you prepared to give?

BEN: First I'll tell you what I can't. I can't tell you who told
me. I can't tell you where I got the order from. I won't
tell you where I put it. But I can tell you certain…put
it this way, I have information I haven't published yet.
Governments that helped us. Exactly where the prisons
are. Some of the names of the interrogators. I have
interrogators' names. And three of the men who were killed.

ROGER: Their names?

BEN: Yeah. And everything else about them. Where they were
captured. When. What happened after they were captured.
The commanding officers. I can tell you a *lot* about these
deaths.

ROGER: Well, I don't see how… I mean, that sounds like a
newspaper story. I don't see how that helps the prosecutor.

BEN: He knows the story, he can deduce the rest. He can look
these people up. He can walk the story back from them to
me.

ROGER: Except that none of them gave it to you. Right? (*He
waits.*) Right? And if they didn't give it to you… He's after
the leak, Ben! Not the story.

BEN: That's the best I can do.

Slight pause.

ROGER: Ben, maybe you don't understand. What you're
dealing with. I mean, you saw this guy in court. In front
of people. You saw him on his best behavior. I saw him
alone. I spent last… (*Getting worked up.*) …I spent THREE
HOURS last night, with this guy, *alone.* And I am telling
you, he…this guy is on a mission. He sees this thing, not
just you, this whole thing…as a death struggle. With Islam.
With *all* of Islam. Not good Islam/bad Islam; ALL of
Islam. I mean, we are locked in a war with him. (*Referring
to the al-Qaeda struggle.*) A thirty-year, a fifty-year war. And

people like him – I mean, this is the way he sees himself – people like him, are foot soldiers in this war. And his job – I'm telling you, this is how he sees it – his job is to create the conditions to win this war. And that means...you know what that means? In part? Controlling the message. Making sure the United States is PERCEIVED in a certain way. And not perceived in another way. And when you publish a story about our country torturing people...killing people...disappearing people...making... (*About to say 'prisons', he instead cuts himself off.*) ...our enemies, our potential enemies, have a reaction to that. As do our allies. Our enemies have something new to fight against. Our allies have another reason not to join us. And so our fifty-year war becomes a hundred-year war. Becomes a war more difficult to win. Becomes a war that's POSSIBLE to lose. And he can't allow that. He *won't* allow that. And so he's going to take a guy like you... I mean, to him, Ben, you're nothing. You're collateral damage. He's going to take a guy like you and break you. If you make him...he'll break you.

BEN: And you won't lose any sleep over it, will you?

ROGER: What?

BEN: It sounds to me like you won't lose any sleep over it.

ROGER: What are you talking about?

BEN: I'm just saying...as you're recounting this, as you're giving me his logic...it sounds like it makes pretty good sense to you as well.

Beat.

ROGER: Okay, I'm just going to disregard –

BEN: No, don't disregard. Talk to me, Roger!

ROGER: Talk to you what?

BEN: Tell me what the FUCK you're talking about!

Beat.

ROGER: Just so we're clear… I don't know if you saw this… couple years ago… Justice Department put out a memo. Sent it to every law firm in the country. You wanna defend Guantanamo detainees? You wanna offer them pro bono service? Well, we're going to tell every corporation in the country that you're doing that. And the fact that we think it's un-American. And let's see how much business you get the following year. (*Beat.*) Okay? (*Beat.*) I'm not helping my bottom line here, Ben.

BEN: So what are you doing?

ROGER: Defending a friend.

BEN: Against what?

ROGER: (*Annoyed.*) What??

BEN: (*Raising his voice as well.*) I just want to know, in your mind, what you're doing.

Beat.

ROGER: You know what I'm doing? At this point. I'm trying to get two people, two very stubborn people, to understand each other. I'm trying to get you to understand, Ben…the degree to which things have changed. We said they moved the goal-posts. We said it's a new day. Well, we didn't know the half of it. These people are not *constrained.* (*This last he says emotionally, revealing just how unsettled he is himself.*) And this guy by the way, in case you…harbor any illusions on the matter is not independent. He is not an 'independent' prosecutor. He is taking orders. I don't know how the orders are getting to him. I don't know who the orders are coming from. But I know…from a slip here, a slip there…that he is taking orders. That this is a priority. That your case…that they see your case as an instrument of *policy.* That they are talking to the nation. They are talking to the press. They are re-*writing* the rules. And they want everyone, on every side, to understand that fact. (*Pause.*)

At the same time, I am trying to get this guy to understand what is at stake here. What it means…to take our country back to Woodrow Wilson. To the Sedition Act. To the Espionage Act. To treating reporters like criminals. To taking a man like you, an honored man, a decorated man, a fucking award-winning journalist…and treating him like a traitor. (*Beat.*) I am trying to make him understand the value of an independent and free press; something I never thought I would be doing…in our country. In America. (*A meaningful pause.*) That's what I'm doing.

BEN looks at ROGER, truly moved – and amazed by what he's just heard.

BEN: (*Shaking his head.*) Christ.

Pause.

ROGER: And Ben I have to tell you, what happened yesterday…it just didn't help anything. It didn't help the communication. It made…there is more distrust now.

BEN: Because he broke the rules!

Beat.

ROGER: Where did you go?

BEN: (*Beat, truly taken aback.*) What does that have to do with anything?

ROGER: I need to know.

BEN: What the fuck does that have to do with anything, Roger? What difference does it make?

ROGER: Ben, you're being investigated.

BEN: Yeah –

ROGER: And you were followed!

BEN freezes at this, totally shocked at this fact.

BEN: What?

ROGER: What the fuck, Ben?? You were followed! (*After a beat.*) They have a crew of people... I mean, I don't even know how many...follow-ing you. They are building a *case*! So, I mean, don't... Don't you think it's important I know as much as *they* do?

Pause.

BEN: They told you this?

ROGER: They asked me questions.

BEN: What questions?

ROGER flips open a pad.

ROGER: Who lives at 1417 E. 8th?

BEN stares at him, not knowing how to answer.

(*Repeating, now for his own information.*) Who lives at 1417 E. 8th?

BEN: (*Shaking his head, petrified.*) I can't do this.

ROGER: Ben, you don't have a choice in the matter.

BEN: (*Growing upset.*) What are you asking me Roger?

ROGER: Who lives at 1417 East 8th?

BEN: Look it up! You have the address, look it up! Right? So that's not what you're asking me. What are you asking me?

Beat.

ROGER: Is Laurel Grayson your source?

There is a horrified silence. BEN simply stares.

They're going to put her on a polygraph. Is she your source?

There is a long pause.

BEN: You know how I work? I try to understand the people I'm talking to. See it from their point of view. Empathize.

Understand what they think their mission is…if they're working in the Pentagon, Intelligence. And because I do that…and I do that over a long period of time…people begin to trust me. They begin to understand that I don't have an axe to grind. That I'm not out to hurt them. (*Long pause.*) You're asking me to hurt them.

ROGER: No. I'm asking you… I guess what I'm asking you is the same thing the foreperson was asking you. To think as a citizen. To forget for a moment that you're a journalist. A friend. And be a citizen.

BEN: I can't do that.

Beat.

ROGER: Well then you're going to jail. They'll make an example of you. It won't be fair. It won't be about you. (*Slight beat.*) But you're going to jail.

Beat.

BEN: For how long?

ROGER: As I said last night, it depends. Worse case, twenty years.

BEN: For the Espionage Act.

ROGER: Yes.

BEN: They'll throw a journalist in jail for the Espionage Act. Because I printed a story, for America, for *American readers* …they'll throw me in jail as a spy.

ROGER: That's not the way they see it, and it's not likely…but yes.

BEN: He said this to you?

ROGER: He threatened it, yes.

BEN: On what basis?!?

ROGER: The paper you have is the property of the United States. It's marked secret. You're not authorized to print it. It alerts the enemy.

BEN: The enemy fucking KNOWS! Roger! Mahkmood isn't there. 'Where's Mahkmood?' 'I don't know.' 'They must have fucking taken him.' They KNOW!

ROGER simply stares at BEN – he's stating the obvious.

(*Finally, cynical.*) But they don't care. Do they? They don't want other people like me printing this stuff. And not because of the enemy either. Because of America. Because they don't want America to know.

Pause.

ROGER: What did she tell you?

BEN: What?

ROGER: Your source. You must have gone there asking for something. What did she tell you?

BEN: (*Furious.*) I –

ROGER: Talk to me, Ben! I'm your lawyer. (*Beat.*) Talk to me!

BEN: What do you want me to say to you Roger?

ROGER: Why you went there. What did you go there for?

BEN stares at ROGER, furious. He is debating whether to answer. But finally he shakes his head.

Ben, they saw you. For all I know, they have the place bugged. They probably already know. Why not tell me, too?

BEN: Roger, it doesn't make any difference. What difference does it make? Why the hell do you want to know?

ROGER: For me to advise you, for me to give you complete ADVICE... I need to know what I'm dealing with. (*Beat.*) Did you ask her to release you?

BEN stares, unable to answer.

Did you ask her to release you?

BEN: Yeah.

ROGER: And what did she say?

BEN: She's afraid. She thinks… (*Then.*) …she's afraid of prison.

ROGER: She gave you the order.

BEN doesn't say anything.

Did she give you the order?

BEN nods.

So it wasn't just…she handed over a document. And that's clearly illegal. (*Beat.*) And Ben, they're going to get her. Whether you give them her name or not, they're going to get her. (*Beat.*) Right? They know. (*Beat.*) So now it's no longer a question of spying, of damage done, of plugging the leak. Now it is a question of the First Amendment. The Fourth Estate. The freedom of journalists. You don't want to let them put you behind bars. That doesn't do anything for the cause. You talk about what will cause a freeze. Having journalists in jail will cause a freeze.

BEN: Yeah, and I give her up and that causes what?

ROGER: That causes nothing. That causes you to write an article. That causes you to write a book. That causes you to keep going. Your family to keep going. Oversight to keep going. The other way, everything gets quiet.

Beat. BEN is being swayed.

Ben, listen to me. There's no easy answer here. You're in a tough spot. I don't underestimate that. But you've got to think clearly. Weigh the consequences. Don't be a fool. (*Beat.*) You won't be a hero. You won't rally the troops. You'll be forgotten. And they'll win.

Beat.

BEN: I can't decide this now.

ROGER: What do you mean?

BEN: I'm not going to decide, Roger… I mean, Jesus fucking Christ! I'm not going to decide if I want to ruin my career…or spend the rest of my life in Leavenworth… I'm not going to decide that in the next ten minutes.

ROGER: (*Looking at his watch.*) Five.

BEN: Rog –

ROGER: (*Cutting him off.*) Ben, again…it's not a choice. The moment for a choice was two weeks ago. Two months ago. Now it's not a choice. Now you're here. The Grand Jury has assembled. They're waiting.

Beat.

BEN: What are my options?

ROGER: In what sense?

BEN: I give up… (*About to say her name, he instead says:*) …say, I give up…my source…what then?

ROGER: He's going to want everything. There's no deal any more. There's no…minimal amount you can give. (*Beat.*) He wants everything.

Beat.

BEN: Jesus.

BEN leans back in his chair, clearly torn. Then, after a moment…

I remember…this is…*years* ago…but I remember walking into the newsroom, little paper I was working for, and have the editor call me over. I admired this guy. I loved him. He had given me my start. He was advancing my career. And he had connections everywhere. Anyway, he calls me over, he says to me… 'There's a hard road; there's an easy road -- which are you going to take?' I didn't know what he was talking about. He and I hadn't discussed…and it

wasn't about me exactly. But it turns out our little paper was in jeopardy. We had written a story, a story I had taken part in, that had stepped on some toes. Some big toes. And the owner had gotten a call from the biggest toe. He wanted a retraction. A say it ain't so story. And the owner said he wanted to give it to him. The toe was connected. And the editor, my hero, told him, no, it wasn't possible. The story was good. We stood by it. And the owner said something tough like… 'It's not a request.' And the editor, guy who was not going to get another job…who was, 55, 60, he seemed older than God to me…he said he wasn't going to do it. He wouldn't print a retraction. The owner was going to have to fire him first. And when I walked in that morning, he was standing there waiting to hear what the owner was going to say to him. He wasn't sure. But he wanted me to know what he'd done. He wanted me to know what he'd felt had been necessary. And I've never forgotten that. Never forgotten the wait that followed either. I mean, he was putting it all on the line. And why? Because he wanted his life to have meaning. He wanted his little shitty-ass paper to stand for something. He wanted to be able to live with himself. (*Beat.*) I've never forgotten that.

Pause.

ROGER: This is your way of saying…what? That you won't cooperate?

Pause.

BEN: I don't know. I'll see. I haven't made a decision.

ROGER: Ben, look, you –

BEN: I'll see! (*Beat.*) Roger, don't worry. You've done your part. You've prepared me. I won't…hold it against you. (*Beat.*) But I don't see why I have to make a decision about it now. Let me get inside. Let me go at it with him again. (*Beat.*) Let's see what happens.

BEN starts for the door.

ROGER: Ben!

BEN turns back.

Aren't you gonna tell me about this guy? Your hero. (*Beat.*) What happened?

BEN: He got fired. I never heard from him again. (*About to turn away, he turns back.*) Actually…that's not true. He placed me. Before he left, he placed me. (*Beat.*) He got me a great job. (*Then, offhandly:*) See you.

And with that, BEN exits – and just as he does, JUDY appears. She is very emotional.

JUDY: (*Sharp.*) And?

ROGER: (*Annoyed.*) And what?

JUDY: What –

ROGER: Judy, I told you, I don't know! I don't know what goes on in that room!

JUDY: But you know what goes on when he leaves you. You know what he said before he went in. What did he say?

ROGER: It was very unclear. In one moment I thought he was…you know, cooperating. Considering it. At another moment he seemed quite…resistant.

JUDY: You told him about the surveillance?

ROGER: Yes.

JUDY: What you told me. How long they've been tailing him.

ROGER: He understands that they've got him if they want him. He understands everything.

JUDY: He just doesn't give a shit.

ROGER: I don't think he thinks it will happen. I don't think he thinks the American Government…will jail a journalist for a story.

JUDY: But you… (*Seething.*) …I hope you made him understand…that they will.

ROGER: I tried.

Beat.

JUDY: Did you see the television? Did you see the way it's being spun?

ROGER: Them?

JUDY: EVERYONE. Liberal networks. Conservative. Doesn't matter. Administration. Doesn't matter. Everyone is saying the same thing. He has an obligation. I saw *one* guy… (*As in ONLY one guy.*) …Olbermann, I think…say something different. And even he… But at least he, you know, said it was part of something larger. Everyone ELSE…said the same thing. We're at war. We have secrets. It's legitimate for us to have secrets. And those secrets cannot be published. I mean, I just don't understand Roger. Why does Ben not see this?

ROGER shakes his head. Unable to answer. JUDY waits for him.

Does he not give a shit? Is he so obsessed with his own *fucking celebrity*…? What is it?

ROGER: (*Beat, quiet.*) I don't know. (*Then.*) But I don't think it's that. I think he believes it's right.

JUDY: And so what's going to happen? Is he gonna… Can they arrest him?

ROGER: For contempt. The judge can put him in jail for contempt. If he doesn't answer. But it looks like he's answering. So, no, on the charges they could bring against him…no. They'll have to draw up charges. There will be a process.

Long pause.

JUDY: Is anyone talking to him? In the paper? On the phone? Anyone?

ROGER: I don't know.

JUDY: (*Suddenly, tears.*) He's throwing away our lives, Roger.

ROGER: I know.

JUDY: He's throwing away our fucking lives!

ROGER: I know. I... I know.

> *Pause.*

> Look, let's see what happens. Maybe he'll surprise us.

> *Pause.*

> I'll call you if I hear something. Okay? (*Then, after a long beat.*) See you.

> *The lights go out on ROGER – remaining up on JUDY...and for a long moment, she simply stares out in sadness. And then the lights go out on her as well.*

> *The TV returns.*

HOST: (*V.O.*) But about your piece. What exactly are we learning?

BEN: A number of things. Actually it's largely a matter of size and scope. Our country is not only doing what we've already learned. Creating secret prisons in foreign countries where we are torturing people. But we are doing so on a far greater basis than we've been led to believe. This isn't 'a handful of people'. This isn't 'the worst of the worst'. This is scores, perhaps even hundreds of people who are rotating through. And these people are brought in without process, without trial, and so some of them are innocent. But regardless of their innocence, they are brought through the same system which includes not only the techniques we've heard about – waterboarding, stress positions – but also other techniques; electroshock, faux electroshock, mock executions, and in three instances what seem to be real executions.

HOST: (*V.O. Astonished.*) Real executions?

BEN: And not executions as a result of punishment...
executions as an instrument of interrogation. In one case,
a man was brought into the cell of another man, the two
having fought alongside each other in Afghanistan, and
shot right in front of him. Bullet put right into his head in
front of him. And the second man, ironically, was found to
be innocent. To not be the man they thought he was. And
so this man was eventually released. (*Slight beat.*) Well, I
have found this man, and I have interviewed him...and
I have gotten from him the name of the first man, a man
whose name is found nowhere else in the records. Until
now. I have an order, a signed order, showing the transfer
of this man to the prison in Romania where he was
killed. In this order, an official document of the United
States government, what's called a 'transfer receipt', the
man's name, country of origin, purported connection to
al-Qaeda, alleged involvement with the first man, are
all listed. This is the document that has caused so much
controversy.

HOST: (*V.O.*) Unbelievable.

BEN: But just the start. I also have...

*Lights come up on ROGER and JUDY, once again, as before, instantly
engaged.*

ROGER: He talked to them.

JUDY: What?

ROGER: He talked to them. I don't know what he said, but he
talked to them.

JUDY: What –

ROGER: Wait. There he is! Ben, what happened? (*BEN enters,
crossing quickly past ROGER.*)

Ben, I got Judy on the phone! What happened? (*BEN
continues crossing the stage.*)

Ben! (*Until finally BEN gets to the door, and turns back to him.*)

BEN: Fuck you Roger. (BEN *then exits. And for a long moment there is a silence. Then…*)

JUDY: What did he say? (*She waits a beat.*) Roger, what did he say? (*And finally ROGER turns out.*)

ROGER: Nothing, he –

JUDY: What do you mean nothing. He must have said something. What did he say? Where is he?

ROGER: He left. I think he's on his way home.

JUDY: But he talked to them?

ROGER: Yes.

JUDY: How do you know that? Who told you?

ROGER: The foreperson. The jury foreperson.

JUDY: Told you?

ROGER: Yes.

JUDY: What did she say?

ROGER: Nothing. Just… Actually, she didn't say anything. It was more a look that she gave.

JUDY: (*Incredulous.*) A look???

ROGER: Yes.

JUDY: She 'looked' at you?

ROGER: Yes.

Beat. JUDY starts to understand.

JUDY: (*A little relieved.*) And you know he talked.

ROGER: Yes.

Another beat.

JUDY: All right, I'll call you when he gets here. (*Then.*) You coming?

ROGER: Call me when he gets there. (*Beat.*) We'll see.

Another beat.

JUDY: Okay. (*Then, after a beat.*) See you.

ROGER: Jude! (*Then.*) Never mind, I…never mind (*Beat.*) I'll see you.

With that the lights go out on ROGER, staying up on JUDY, as we hear the sounds of a newscast…

VOICE: (*V.O.*) What we know…here's what we know. Benjamin Kritzer appeared for a second day in front of the Grand Jury.

The lights start to come up on BEN – sitting alone now, facing the television. JUDY stares at him. He's been drinking. Heavily. In fact he is very drunk.

He was before them for more than two hours. And during that time it was thought he answered the question that has been central to this investigation from the start; who gave him the so-called 'secret order'.

SECOND VOICE: (*V.O.*) Laurel Grayson.

VOICE: (*V.O.*) Laurel Grayson, yes.

JUDY: Can –

BEN: (*Annoyed.*) Not…yet.

JUDY: Do you want another? (*Referring to a drink.*)

BEN: No.

JUDY turns to where BEN is looking, the TV, the sound of the voiceover by now having died out.

JUDY: Did she come on again?

BEN: No.

JUDY: Just –

BEN: The perp walk. Just the perp walk.

JUDY: I wouldn't call it that.

BEN: (*Snapping, sharply, almost yelling.*) What would you call it? She's in handcuffs. The media's there. What would you call it?

At this we see a large photograph of an older woman, an elegant older woman, tall and erect, leaving a townhouse in Georgetown. She is in handcuffs. Her eyes dart about. It is the photo being shown on the evening news.

JUDY: What did they say about her?

BEN: Nothing, just… (*Then.*) …nothing.

JUDY: Nothing?

BEN: That she worked for the Agency. That…

He shakes his head, not able to continue. He is near tears.

JUDY: Ben –

BEN: I don't want to talk about it!

His words are slurred.

JUDY: All right. (*Then, after a moment, growing uncomfortable.*) All right, I'll –

BEN: Don't leave.

This last he says as she'd started to stand. Again she sits.

Don't leave.

JUDY: (*Gentle.*) Let's turn this off.

With that, she walks over to the TV and turns it off – the image of the woman fading as she does so.

BEN: You remember what happened right after the column?

JUDY: (*Beat.*) What?

BEN: People came up to me, came up on the street, saying 'I agree with you.' 'I agree with what you're saying.' 'Keep saying what you're saying.' (*Adding, disdainful.*) Liberals. (*Beat.*) 'Course, they were whispering; they wouldn't say it out loud. And the minute the Establishment rose up against me, they vanished into thin air. But they agreed with me. They – (*Beat, bitter.*) You don't think they still would?

JUDY: (*Beat.*) Not…no. You read the polls, I'd say, no…they wouldn't.

BEN: I'm not saying now. I'm not saying five years later everything's beautiful. I'm saying five years later after another terrorist attack. You don't think they'd still agree with me? (*Bitter, angry.*) That maybe a little torture might not be okay? That maybe we shouldn't be so *'squeamish'* about it?

JUDY stares at him, not answering. BEN is clearly upset. And very drunk.

You're wondering why I'm asking. Because I'm sensing hypocrisy, that's why. I'm sensing the same fucking hypocrisy. And I'm tired of it. I'm tired of everybody whispering. 'Yeah, sure, go ahead. Say it brother.' And I say it out loud and I get my fucking ass handed to me. I'm tired of that! (*Beat.*) Fuck it! (*Beat.*) Whole fucking thing. Whole fucking generation. Whole… You see, that's the thing here. You ever wonder… I mean, think back. You ever wonder about the end of the Vietnam War? Those last couple years? You ever wonder about that? (*Beat.*) Where did all the protesters go? You know? They *vanished.* Nixon created a volunteer army, signed a peace deal, the kids were off the streets. Where'd they go? The war went on. We were supporting Thieu's government for two more years! But the kids were gone. Why? Because it wasn't about what we said it was, that's why. It wasn't about Imperialism. It wasn't about 'war' being wrong. It was about self-interest. *Our* self-interest. Once we weren't going

to get shot, once OUR asses weren't on the line, we could GIVE a fuck about other people. You see what I'm saying? We deluded ourselves. Our whole fucking generation *deluded* itself. We thought we were better. More humanistic. More… 'enlightened'. (*Continuing, shaking his head.*) We weren't. We were just better at P.R. We had internalized the lessons of the 50's…'99 out of a 100 dentists agree!'…and applied it to our whole fucking generation. But it was a lie. And today…when we're attacked…when those buildings come down…our generation responds. Same generation. 'Cause now it's *us. We're* in power. And our response is 'Fuck 'em. Kill 'em. Nuke 'em'. Flower power? Oh, yeah… (*Then, sneering.*) …flower power is dead.

JUDY: (*Pause.*) You talked to them?

BEN: What?

JUDY: Is that why you're –

BEN: (*Yelling, defensive.*) I can't say to you what I really believe!? I can't talk without you thinking I have a secret motive? I'm just trying to sort out what I'm thinking here. We're all *liars.* That's what I'm saying. To ourselves. To each other. We purport to believe one thing…and in fact we believe something that's almost the opposite. But look, it's… (*Lashing out, drunken.*) I'm trying to talk to you about who we are. Do you want to talk to me about that?!

This last he spits out to her angrily, as a challenge.

JUDY: Sure.

BEN: (*Sloppy, slurring, indulgent.*) Because I think it's important. How we've come to where we have. I mean, think of it. I… (*Then.*) When we first met…what was it that made us mad? That joined us? Our outrage at Reagan. That he would roll us back. That he had so much disregard…and we still thought that Abbie Hoffman *meant* something. *Steal This Book.* We still thought…that the lessons of the 60s were valid. That the struggles of liberation…for women, for civil rights…for the Vietnamese, for indigenous people…for

Indians. We still thought…for gay people…that it wasn't all fucking self-interest! That there was such a thing as altruism. That we could think outside…you know, outside what was good for us as individuals and instead could think of what was good for others, that in *turn* was good for us. (*Pause.*) But that whole idea turns out to be a lie. There's no such thing as… All anybody can *think of* is self-interest. And so now our self-interest is survival. People are attacking us, we're interested in surviving. And this is all connected to that.

Pause. He's done. JUDY waits to make sure he is. Then…

JUDY: (*Gently.*) Tell me what happened.

BEN looks over at her. A moment passes.

BEN: I did what they wanted. I gave her up.

JUDY: Your source?

He nods.

JUDY: Why?

He leans back, head against cushions.

BEN: Because they had her. And the only one who was going to be hurt if I didn't was me. You. Our family. And that didn't make sense.

JUDY: What did the paper say?

BEN: They supported me. I called them, they supported me.

JUDY: (*Defensive, on his behalf.*) As well they should. You've fought this for ten months now. More than that. A year! They couldn't expect more.

BEN: They don't. (*Amending that.*) They say they don't.

JUDY: They don't.

BEN: We'll see.

Beat.

JUDY: Ben –

BEN: Judy… (*Suddenly in tears, sobbing.*) …I did a bad thing.

He reaches for her, grabbing her to him.

I did a bad thing. I did a bad thing.

JUDY: No, you didn't.

She is stroking him.

No, you didn't.

But for several more moments he is crying – sobbing – all the weight and pain of events crashing down on him. He keeps crying 'I did a bad thing.' He cries it over and over.

Till finally, regaining a small bit of composure, he whispers…

BEN: I did a bad thing.

JUDY: (*Gently.*) What?

Pause.

BEN: The government, money, power…will always put pressure. They will always try to suppress. And the one thing that stands against all that is the integrity of the reporter. If a witness steps forward, a whistleblower, and wants to tell a story… NEEDS to tell a story…*needs* to tell that story because she has been part of it. The one thing that *allows her*…to tell that story…with honesty and courage…with…the one thing that *allows* her to tell her story is the notion that she can do so in confidence that the reporter will not turn her in. (*Beat.*) I turned her in. (*Tortured, crying out.*) I turned her in.

Pause.

That's what I've done.

JUDY: But you've done other things as well. You've *made* the story. You had the guts, Ben…very few people did…you had the *guts*…to make this story. Which will have an effect. HAS had an effect. And I'm sorry, but I… I just don't think it's right to put this whole thing on you. YOU have to carry that weight? You? Who said? What about your newspaper? Where do they fit in? You know this is all very convenient… (*New thought.*) …and I must say, I find it *shameful* that they didn't have attorneys there. You talk about assets? Where's your goddamed newspaper? They should be flooding that place! There should have been 50 fucking attorneys in those hallways. And instead there's *Roger*??? You and Roger??? What the hell is that? And –

BEN: Roger was paid for by them.

JUDY: Well, whoop-dee-doo! That –

BEN: We *asked* them…they would have been happy to have attorneys there. We asked them…to leave us alone. (*Beat.*) If there had been attorneys there, they would have pressured me not to give her up. To stand tough with the prosecutor. We asked them to give us some space. (*Beat.*) You can't fault them.

JUDY: Well, I don't fault you either. I don't fault a man in a marriage, with children…who has responsibilities to a great many people. Your mother! I don't fault you either. This wasn't two weeks in jail. This wasn't a contempt citation. This was years. Roger told me this was years!

BEN is nodding.

BEN: It could have been years. I don't think it would have been. But it could have been.

JUDY: I don't fault you for that.

There is a silence.

BEN: (*Soft.*) Do you love me?

JUDY: Yes. (*Beat.*) Very much. I think about what you did. How you could have done it differently. But for us. Very much.

Suddenly ROGER appears in the doorway.

ROGER: Charges dropped. Free and clear.

BEN: (*Looking up, subdued.*) Great.

ROGER: Against Laurel Grayson.

BEN and JUDY both look up now. Startled.

They don't want to make her a martyr. They arrest her, they gotta arrest everybody who did anything *like* her. And that includes a *lot* of people. (*Slight beat.*) So she's walking. She's losing her pension…but she's walking.

Beat.

JUDY: How do you know this?

ROGER: What?

JUDY: She was just arrested. How –

ROGER: It's not done yet. But that's what's going to happen. I talked to a… (*He stops a moment, searching for the word.*)

BEN: (*Jumping in, sardonic.*) A source.

ROGER: (*A trace amused.*) Somebody working for the prosecutor. An assistant. And that's what they're going to do.

JUDY: (*Beat, upbeat.*) Well, that's great. That's… (*She turns, looking at BEN.*) Isn't that great, Ben?

But BEN doesn't respond.

ROGER: Ben?

There's still no response.

Ben, look, she –

BEN: When did you know about this?

ROGER: What?

BEN: (*Getting worked up.*) How long did you know about this, Roger? What deal did you cut?

ROGER: Ben –

BEN: (*Losing it.*) You coming in here telling me she's walking. How much of this did you KNOW, Roger!

ROGER: I knew none of it. I knew if you didn't cooperate you were going to be in trouble. And I knew, or I thought… I knew…that I could help you cooperate.

Pause.

BEN: You afraid I'm gonna have you disbarred? You afraid if you tell me the truth I'm going to get you in trouble?

ROGER: (*As with a child.*) No, Ben.

BEN: Tell me the truth, Roger.

ROGER: Ben –

BEN: Tell me the truth!

Pause.

ROGER: Look, the world I'm in is a very small world. We know each other. The prosecutor… I went to law school with a close friend of his. I heard from this friend. I don't… there wasn't a deal cut. But yes, I had a sense of how things would go.

BEN: You told him about Sofer, didn't you? That's how he knew what to ask me.

ROGER: (*Patient.*) No, Ben, *you* told him about Sofer.

BEN: (*Getting heated.*) Who ELSE was in the room, he said. He knew someone else was I the room. And once I said Sofer, he had a thousand questions for me. Right on the spot. You told him about Sofer.

ROGER stands to leave.

ROGER: I gotta go.

BEN: Didn't you?

ROGER: Judy, I –

BEN: DIDN'T YOU??? (*Then, after a beat.*) Why?

Beat.

ROGER: Because that's how you play it in this town. And that's how you win.

Beat.

You're a free man, Ben. *Mazel Tov.* (*Then, nodding to JUDY.*)

ROGER exits – and JUDY and BEN are left alone.

JUDY: Ben…

Only to be replaced by the television images – once again BEN in the midst of his interview…

HOST: (*V.O.*) Yet I have to ask you this. There are some who suggest you're being hopelessly sentimental. In your outrage at this. That even in 'good wars' we've hurt the innocent. Targeted civilians. Dropped bombs… (*Sudden idea.*) …the bombing campaigns in Germany. (*Slightest beat.*) What do you say to that?

BEN squirms.

BEN: (*On TV.*) It's a good point.

HOST: (*V.O.*) Is it any different?

BEN: (*On TV.*) I think the difference…

He's thinking, trying to come up with an answer.

I guess the difference is we're watching. This time. We have a role to play.

HOST: (*V.O.*) So if we were 'watching' during the Roosevelt administration, Truman…we would have asked them not to drop the bomb?

BEN: (*On TV.*) It's not 'we' alone. The *world* is now watching. And it's going in slow motion. This isn't happening day after day, gathering momentum. This is happening in slow motion. You can see the liberties being stripped away. The prerogative being taken.

HOST: (*V.O.*) Is it also the difference in threat? That fascist Germany, Japan could literally overrun America. And this terrorist threat, dangerous as it is, is lesser?

BEN: (*On TV.*) Yes, I think that's… (*Then, almost grateful.*) …yes.

BEN waits for a follow-up…but clearly he is being asked to amplify.

(*Finally.*) Yes, I think you're right, that's… (*Slight beat.*) And so whatever comparisons may… We have to ask if we're… (*Beat.*) But I think you make a good point.

Pause. BEN looks out. He knows his answer is incomplete, unsatisfactory. And yet he doesn't know how to continue. Then…

If we actually believe that…our civilization is about to end. That save for desperate measures we will be vanquished. Utterly defeated. Taken over. I suppose if we believe *that*…all options are open. We can incinerate a quarter, a half a million other people…to save ourselves from that fate. (*He takes a long moment, making sure his audience attends him.*) But if we believe, as I think is the case here, that we are actually far stronger than our enemy. That his powers, though *shocking* when he uses them…are actually rather minor. That our civilization is in fact not at *all* at risk. That what we are dealing with more resembles Pancho Villa than it does Imperial Japan…then I think the fact that we are willing to put our nation's values at risk in the pursuit of him is a mistake. (*Beat.*) Our enemy detests us, there is no doubt about that. And if he could, he would destroy us. But he can't. Much as he might wish to do so, he can't.

And we must not, in our fear of him, destroy ourselves on his behalf.

Suddenly the TV image goes black…and lights again come up on the scene from the start, but this time the hooded man is slumped, wrung dry, and the masked man is breathing heavily. The masked man then dunks the rag one more time and removes it from the basin, the sounds of the water dripping loudly on the floor.

Suddenly the masked man removes the hood from the seated man – and for the first time we see who it is. It's BEN. And BEN looks up wild-eyed, his mouth taped closed with gaffer's tape. Shaking his head with terror, BEN tries to pull away when the masked man again affixes the rag to his face. But he can't. And instantly, when the rag is affixed, BEN's legs shoot out, spasmodically, his body writhing in terrible pain. We watch this for some time, until finally his body stops moving…and the man in the mask removes the rag.

And BEN, in that instant, takes a huge breath.

And a moment passes. Before the masked man, for the first time, speaks. His voice has an edge.

MASKED MAN: Say again?

BEN continues struggling to breathe, the masked man breathing heavily as well – when the question is repeated, this time even more angrily.

Say again!!!

Till finally, in a weakened voice, BEN gasps out his response.

BEN: Perhaps we…shouldn't be…so squeamish.

At this, the masked man nods his head, and then backs out of the room… As the lights slowly fade to black.

End play.